SOLDIER FIELD

A POMEGRANATE
BUILDING BOOK

JAY PRIDMORE

PHOTOGRAPHY BY
DOUGLAS REID FOGELSON

Pomegranate

SAN FRANCISCO

Published by Pomegranate Communications, Inc.
Box 808022, Petaluma, CA 94975
800 227 1428; www.pomegranate.com

Pomegranate Europe Ltd.
Unit 1, Heathcote Business Centre, Hurlbutt Road
Warwick, Warwickshire CV34 6TD, UK
[+44] 0 1926 430111
sales@pomeurope.co.uk

Library of Congress Control Number: 2005903915

Pomegranate Catalog No. A783

Cover and book design by Lynn Bell, Monroe Street Studios, Santa Rosa CA

Printed in Korea

14 13 12 11 10 09 08 07 06 05 10 9 8 7 6 5 4 3 2 1

FOREWORD

In 1919, the South Park Commission concep-
tualized Chicago's first, large-capacity, out-
door arena as a multiuse venue that could
accommodate 100,000 spectators.
Completed in 1925, the structure was
named Soldier Field, in tribute to World
War I veterans.

For seventy-five years, Soldier Field was
the setting of historic events, including the Dempsey-Tunney boxing match in
1927 and the Chicago Freedom Rally organized by Dr. Martin Luther King Jr. in
1966. Its association with these and other momentous events earned Soldier
Field National Historic Landmark designation.

By 2000, Soldier Field could not meet modern-day needs. Again, city leaders
sought to create a venue that would attract a gamut of events, but this time the
architects shouldered the delicate task of updating the arena's functionality
while preserving its landmark features. Public release of renovation plans
sparked a debate that resonated throughout the city and inspired more dialogue
than ever imagined. Historic preservationists, sportswriters, veterans, and archi-
tects all offered their views on the design's bold combination of old and new.

After twenty months of construction, the renovated Soldier Field debuted as a
shining example of adaptive re-use. While its historic integrity has been beauti-
fully preserved, the stadium also boasts some of the country's most modern,
state-of-the-art facilities. The success of the renovation can be attributed to all
those whose expertise enriched the legacy of this great architectural icon.

—Timothy J. Mitchell, General Superintendent & CEO, Chicago Park District

Acknowledgments

This book was inspired by the energetic and sometimes clamorous effort by the City of Chicago and its citizens to harmonize its rich architectural heritage with its growing needs for the future. Architecture, like politics, is often a contact sport in Chicago, and to say that the development of a new Soldier Field exemplified this would be an understatement.

Many people helped the author understand the history of old Soldier Field and the process of building the new one. Among them were officials and employees of the Chicago Park District, which is the stadium's owner. General Superintendent Tim Mitchell was an early supporter and promoter of this book, as were others at the Park District, including Julian Green (now on the staff of US Senator Barack Obama), Michele Jones, photographer Brook Collins, historian Julia Bachrach, and archivist Bob Middaugh.

Also indispensable were individuals who work for LW+Z, the architectural partnership created to design the project and present it to the public. Among them, Joe Caprile, principal of Lohan Caprile Goettsch, Chicago, and designer Tony Montalto of Wood + Zapata, now of New York, helped bring the new design into focus. Historical files and other information were made available by the marketing personnel at both firms: Matt Larson and Susanna Craib-Cox of Lohan Caprile Goettsch, and Melissa Koff of Wood + Zapata. Also important

were Peter Lindsay Schaudt, landscape architect, and Luca Serra, of SMG, which serves as on-site manager of Soldier Field.

Recent images of Soldier Field were made by Douglas Reid Fogelson (www.drfp.com/773-395-9433), David Seide of Defined Space (www.definedspace.com/312-733-8233), and Joe Patrick of Lohan Caprile Goettsch. Archival photographs are mostly from the Park District Archives; the excellence of their reproduction is due to Paul Lane at PhotoSource, Evanston, Illinois. Some important archival images came from the Deering Library at Northwestern University through the courtesy of art librarian Russell Clement and multimedia specialist Dan Zellner.

Thanks also to the staff at Pomegranate. Their enthusiasm for the Building Books series has made it possible to present Chicago architecture with a clarity that brings an undeniable monument of Chicago to a new and larger audience.

1919 The City of Chicago and South Park Commission announce plans for a new "Grant Park Stadium" on land to be reclaimed from the lake. After a design competition, Holabird and Roche are named architects for the project.

1924 Two sides of the stadium are completed, and sporting events, primarily football, are played in a stadium with open ends.

1926 The south end, a curved "amphitheater," is completed, and Soldier Field is officially dedicated as a memorial to the veterans of World War I. The dedication is accompanied by the Army-Navy football game, played to a 21–21 tie.

1927 Gene Tunney defeats Jack Dempsey in a heavyweight championship bout that ends after the famous "long-count" gives the victor a second chance. Tunney had been knocked senseless in round 7.

1939 The Chicago Park District builds its headquarters on the north end of Soldier Field, enclosing what had been an open view to Field Museum.

1954 An international ski jumping championship is staged, one of many one-off events in a stadium that no sports team called its permanent home.

1959 Mayor Richard J. Daley solicits ideas to replace Soldier Field with a modern stadium. Proposals cannot overcome preservationists' concerns that a conventional football venue would deface the lakefront.

1971 The first of many remodelings makes Soldier Field home to the Chicago Bears, who had played in the smaller confines of Wrigley Field.

1983 Soldier Field is granted a place on the National Register of Historic Places, making it a National Historic Landmark. The Bears and many

of their fans, meanwhile, increasingly complain that facilities are inadequate for big league football.

1989 Governor Jim Edgar and Bears president Michael McCaskey begin planning a domed stadium south of McCormick Place. The idea, nicknamed "McDome," fails several attempts to win funding from the state legislature.

1996 Despite feuding between the Bears and Mayor Richard M. Daley— and the Bears' threat to move to Gary—the City of Chicago proposes a retractable dome over the existing Soldier Field. After initial designs, the idea is scrapped.

2000 Bears president Ted Phillips reaches agreement with the city for a new stadium to be built as an adaptive reuse of the old one. Bears unveil an unconventional architectural plan, designed by the Boston firm of Wood + Zapata.

2001 Ground is broken hours after the final football game of the year. Fast-track construction begins despite lawsuits, filed primarily by Friends of the Parks, to have it stopped.

2003 New Soldier Field opens to mixed reviews of its design and its football team. The *Tribune* thrashes the architecture; *The New York Times* lauds it. Bears lose the first game in their new home to the Packers but the following week rally at home to beat the Raiders.

2004 Architect and feisty critic Stanley Tigerman predicts that Chicago will come to love the new stadium as it once loved its fabled stockyards.

When Chicago's city fathers conceived Soldier Field in 1919, available tenants were few. The Chicago Bears—then the Staleys—were playing in Decatur; the Cubs and the White Sox had recently settled in their new ballparks. But Chicago was the fastest-growing city in the world, and its leaders were making plans to be the largest. Chicago always led the way. It had the first (and occasionally tallest) skyscrapers. It claimed the world's greatest engineering feat when it reversed the flow of the Chicago River. It boasted a grand lakefront, developing in stages and which local politicians wanted to mark with the world's largest stadium.

In 1909, architect and planner Daniel Burnham had published the *Plan of Chicago*, detailing his ideal city of wide boulevards radiating from splendid parks. The Plan's lakefront had islands and lagoons and an "athletic field, with central gymnasium, outdoor exercising grounds, ... and other such features ... advisable in playground parks." For Chicago's ambitious officials, an immense stadium was logical. Burnham's *Plan* included his famous exhortation, "Make no little plans. They have no magic to stir men's blood." Stirred by Burnham's words and a history of viewing anything as possible in the city, the park and city commissioners made no little plans for their stadium—they seemed driven by a "if you build it they will come" mentality.

Soldier Field was an act of faith in the early 1920s when it was built. It has gone through several permutations since, most recently as a state-of-the-art

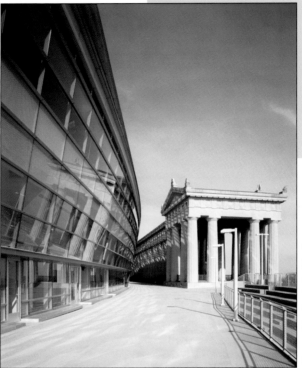

Photograph by Douglas Reid Fogelson

On the stadium's east side, the colonnades of the old structure con-
trast with the curves, diagonals, and reflections of the emphatically
modern design. Old Soldier Field has become a classic in the 80
years it has graced the lakefront. The new stadium's design has
drama and picturesque blends of the antique and modern, but any
verdict on the renovation as a whole must stand the test of time.

Facing page: As Daniel Burnham had imagined Chicago's lakefront in splendid
artistic terms, so did the architects paint a picture of Grant Park Stadium on a
redeveloped lakefront as a monument worthy of a world capital.

Below: Perhaps not by intention, Soldier Field's most flattering angle today.

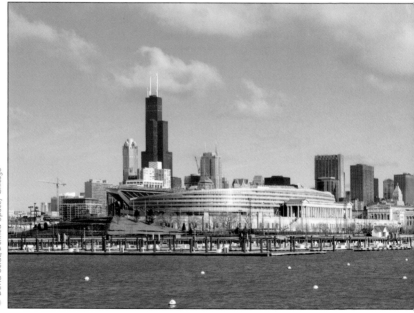

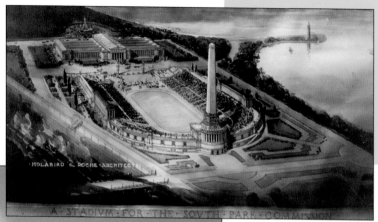

HOLABIRD & ROCHE ARCHITECTS

A STADIVM FOR THE SOVTH PARK COMMISSION

Courtesy Chicago Park District Archives

From the vantage point of Lake Michigan, the symmetry
of the old overcomes the asymmetry of the new.

facility for America's most popular sport. Most recently, it was also a sign of a political will—to spend more than $600 million to modernize a football stadium that is used for the purpose perhaps ten or twelve times a year. Quite naturally, Soldier Field and the new grounds all around it have been the site of great excitement and significant controversy.

A GREATER LAKEFRONT FROM LESSER MARSHES

The shore was notable for the marshlands and swamps that gave rise to the onions— *checagou* in the native language—for which the city was named. Chicago's lakefront developed over time, pushed by varied forces. Deliberate development began in the 1850s. The city gave the Illinois Central Railroad right of way south along Lake Michigan in exchange for a much-needed breakwater at the mouth of the Chicago River. It was a Faustian bargain but an urgent one, as the lake was eroding the shoreline, and nearby property owners feared being left with nothing. Happily, the railroad's work stabilized the shore, which was not yet beautiful but was inspirational, as engineering demonstrated how the the lakefront could be not

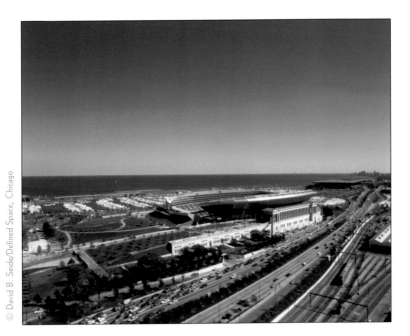

The lakefront has been altered time and time again in Chicago's history. Among its landmarks are McCormick Place in the distance, train sheds along the right of way, and now an unabashed example of early-twenty-first-century architecture.

just saved but enlarged, or "reclaimed" with bulkheads and fill. The result was what we now know as Grant Park. The Great Chicago Fire of 1871 had its effect on the story as well, reducing most of the city to rubble but providing a ready and plentiful source of landfill, whereupon lakefront development

continued apace. At first, perhaps, this was done without much forethought. By 1909, however, Burnham's *Plan* served as a manifesto to instill the urban planning principles of imperial Europe in democratic America. Burnham and partner Edward H. Bennett designed and promoted a city encircled by green space and marked with boulevards, civic monuments, and perhaps most importantly, a splendid lakefront. There were practical defects to the *Plan,* of course, and among them was what to do with often unsightly railroads. But the idea was presented with beautiful illustrations, and most Chicagoans, especially the powerful ones, endorsed it.

Meanwhile, Marshall Field died in 1906, leaving $9 million for a museum that was expected to become the centerpiece of Grant Park. Burnham imagined other cultural institutions adjacent—a rebuilt Art Institute and the John Crerar Library were clustered together with almost imperial grandeur. For better or for worse—it was thought for the worse at the time—this plan collided with a lawsuit brought by mail-order merchant Montgomery Ward, with headquarters on Michigan Avenue. Ward opposed the scheme, prevailing in court with the argument that the lakefront be preserved as "forever open, clear and free" of buildings.

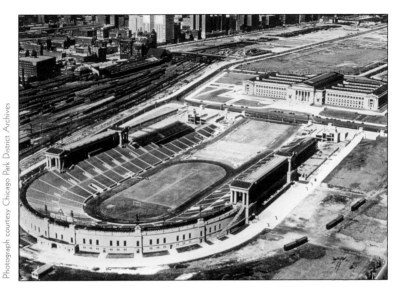

This aerial view shows the beginnings of what became Burnham Park and the Museum Campus, with axial symmetry and classical repose on land reclaimed from Lake Michigan. Both Soldier Field (completed 1924) and the Field Museum (1921) were set east of the Illinois Central tracks, which were an eyesore when they ran directly along the lakefront. Instead of moving the tracks, the city fathers moved the lakefront.

So planners sought an alternative, and were desperate by late 1911 when the Field bequest was due to expire if a public site for a new building were not found. That was when Stanley Field, Marshall Field's nephew, and other

business leaders struck a deal with the Illinois Central, which would cede their rights to several acres that it had reclaimed at the end of Roosevelt Road in exchange for a like-sized site closer to Michigan Avenue. There a station would be built by the railroad, which would electrify its lakeshore line and sink the tracks below grade in an overall beautification effort. As it turned out, this was only the beginning of a much larger series of projects. Eventually the city and the South Park Commission reclaimed a greater lakefront initially for the museum, and later all the way to Hyde Park. The 5-mile strip would be called Burnham Park, after the architect who died in 1912.

CLASSICAL COMPETITION

The year 1919 was a moment to reflect on US victory in World War I, and discussions of lakefront development led to a proposal for a war memorial stadium to grace the park. The stadium would be large: "Chicago is going to have the largest open air gathering place in the world . . . to seat 100,000. . . ." the *Tribune* reported. Voters in the South Park district approved a bond for work to begin. Also key, the Park Commission made a deal with the Chicago Tunnel Company then building an underground network to transport coal,

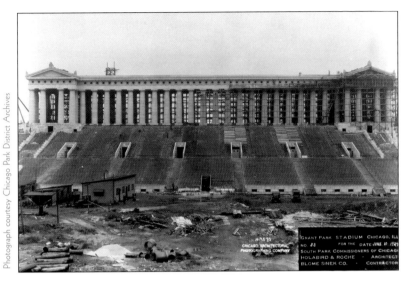

GRANT PARK STADIUM CHICAGO, ILL.
NO. 83 FOR THE DATE JUNE 10, 1924
SOUTH PARK COMMISSIONERS OF CHICAGO
HOLABIRD & ROCHE · ARCHITECT
BLOME SINEK CO. · CONTRACTOR

The material for Chicago's classical temple was concrete, not marble, and it sat on reclaimed land by Lake Michigan. But proportions of the original stadium remain sublime, although now invisible from the interior.

merchandise, and other materials among buildings in the Loop. As part of this project, the company was induced to build a southbound spur to bring in tons of excavated dirt to fill in the lake and to build the Grant Park Stadium, as it was being called. Meanwhile, a veterans group moved to name the place Soldiers' and Sailors' Stadium.

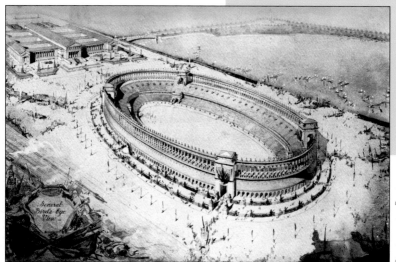

In a city that was excited about neoclassical monuments in museums and even office buildings, the opportunity in 1919 to design something so reminiscent of ancient Rome drew several distinguished architects to the competition. This proposal was by Benjamin Marshall, who also designed the Drake Hotel.

Five Chicago firms vied for the design commission. Competition rules stipulated that Grant Park Stadium be classical in design (even though Chicago's most famous football venue was the University of Chicago's Stagg Field, a Gothic affair). Its architecture would resemble ancient Greece and Rome and, most importantly, recall Chicago's triumphant World's Columbian Exposition of 1893. The design

had to harmonize with—not overshadow—the Field Museum, a Beaux Arts marble masterpiece by Graham, Anderson, Probst and White, just being completed. The winner, Holabird and Roche, proposed a reinforced concrete structure dressed in concrete blocks cast to resemble stone. Their design would be strictly symmetrical, with two straight and identical sides—the better for military parades—each surmounted along the terrace by Doric colonnades. The open end at the north would be dominated by the Field Museum's south facade.

Others who entered this competition had more splendid drawings. They included Benjamin Marshall, who designed the Drake Hotel, and Zachary T. Davis, who designed both Wrigley Field and Comiskey Park. Holabird and Roche were known for functional buildings that might include a bit of antique distinction. They had designed, for example, City Hall–County Building (1911), a simple loft with the grandeur of an external colonnade. Their Soldier Field would have a grandeur and stateliness, too, but what made them the first choice was mostly practicality. Their stadium could, for one, be done in phases; the south end of the structure was in fact delayed for two years due to unavailable funds. They also promised exhibition space beneath the stands and shops on the east side, so buildings could enjoy multiple revenue streams, although neither was completed. They did create, however, a grandstand capacity of 120,000 seats.

Enthusiasm for the project was overwhelming, which did not mean that the Roche design did not draw some fire. Sightlines were long and low, for

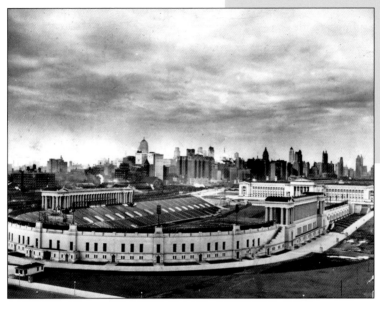

The original architectural program of Soldier Field maintained a low profile so as not to overshadow what was regarded as the great jewel of the lakefront at the time, the Field Museum.

one, and the width of the field between the grandstands precluded baseball. Billy Callahan, former White Sox manager, warned Ed Kelly, park commissioner and future mayor, about these faults, and Kelly made these objections known, but John Barton Payne, president of the South Park Commission, liked the plan that he saw and had it built.

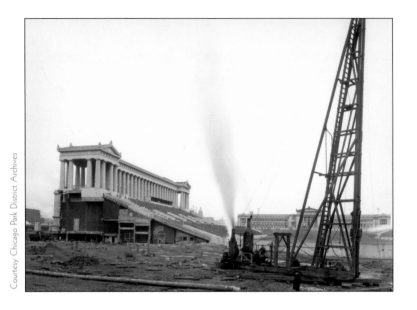

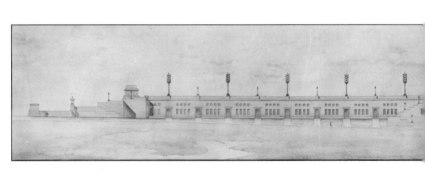

Facing page: During the early 1920s, Chicago extended its lakefront, sank wooden pylons into the soggy ground, and constructed its own version of the Parthenon of Athens with poured concrete and smooth blocks of faux limestone.

Below: More than the others, the winning entry from Holabird and Roche had long, straight sides which were regarded as well suited to military and other parades that the stadium was designed to host.

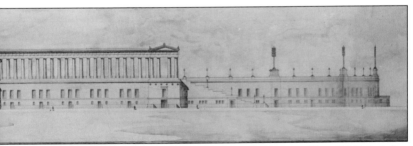

Drawing courtesy Chicago Park District Archives

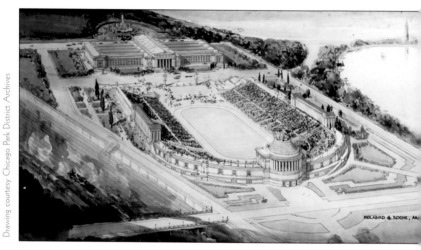

The architects of Soldier Field were
pleased to make the Field Museum
integral to the stadium's original design.

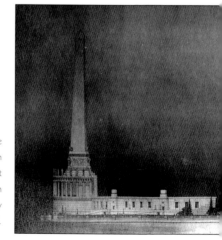

The original Holabird and Roche design was the
simplest among those submitted in the design
competition for Grant Park Stadium. What it
lacked in neoclassical extravagance it would gain
in scale and the immense obelisk (never actually
built) to honor the veterans of World War I.

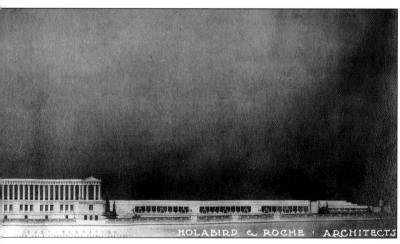

EAST ELEVATION

HOLABIRD & ROCHE · ARCHITECTS

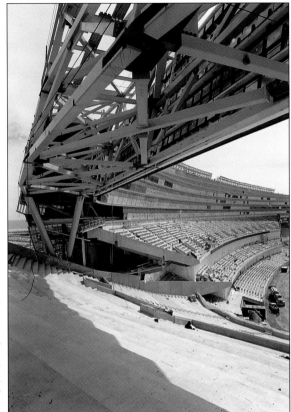

(Before) The dramatic cantilever over the south end of the stadium required engineering that is entirely modern. The section was constructed to hold one of the two high-definition scoreboards.

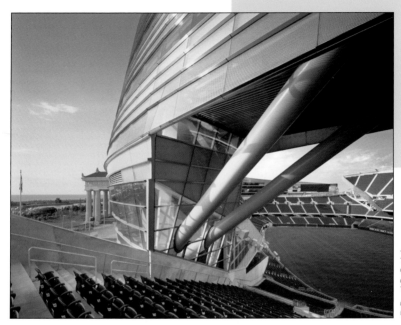

(After) The dynamic grandeur of the new stadium is in its powerful
diagonal supports and gleaming strips of glass, which someday may
be recognized as classic elements of twenty-first-century architecture.

Soldier Field from the south is part of an impressive architectural tableau.

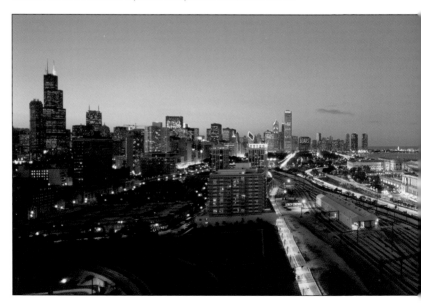

The gradual slope of the grandstands in Soldier Field was never ideal for being close to the action on the pitch. A low terrace to complement the museum and a stately colonnade were priorities.

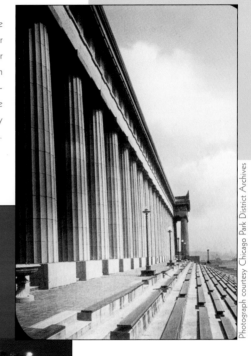

Photograph courtesy Chicago Park District Archives

© David B. Seide/
Defined Space, Chicago

The first large event at Municipal Grant Park Stadium was a football game in November 1924, with Notre Dame's "Four Horsemen" team beating Northwestern by a touchdown. In fact, the stadium was unfinished, without the connecting curve at the south end. But it was still immense enough to hold the 1926 International Eucharistic Congress, with more than 200,000 Catholics assembling from around the world, the largest crowd ever to fill Soldier Field.

Later in 1926 the amphitheater was added at the south end, completing the structure and inspiring talk of bringing the Olympics to Chicago. Nothing developed on the Olympic front, but local politicians did wrangle the 1926 Army-Navy Game, on which occasion Soldier Field was formally named and dedicated. The game ended in a tie, though Walter Eckersdall of the *Tribune* wrote that it was "one of the greatest football games ever played, before . . . the largest crowd that ever saw a football game in this country."

The yearly College All-Star Football Game was initiated there in 1933. For 43 years the game was a true summer classic, sometimes a thriller, although mostly significant for what some players accomplished later. In 1935, for example, the Bears beat a team that included Irv Kupcinet from North Dakota State and Gerald Ford from Michigan. Since 1934, Soldier Field has hosted the Prep Bowl, the annual city championship between the Public and Catholic League champions. In 1937, Bill De Correvont's Austin High dismantled Leo, 26–0; attendance

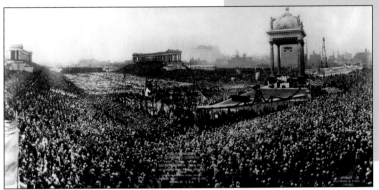

The International Eucharistic Congress, a major event for Catholics worldwide, was held in Chicago in 1926 and filled the open-ended stadium with more than 200,000, its largest crowd ever.

was 120,000, which would stand as the record for football. Alas, Soldier Field didn't attract enough such events, although some were unique. In 1937 a ski jump was erected, drawing the largest crowd ever to attend a skiing meet. In the 1940s, the Chicago Rockets were the local entry in the new All-America Football Conference.

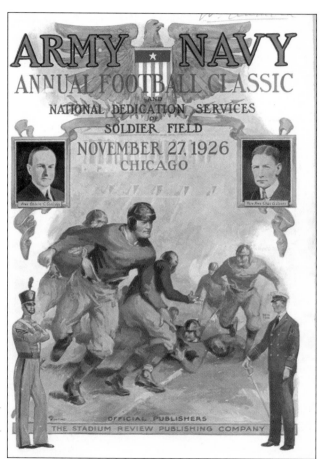

Front cover of the program for the 1926 Army-Navy game.

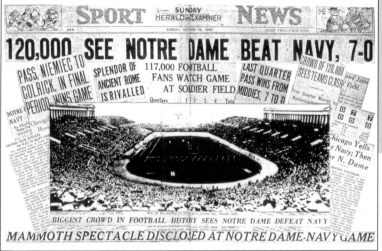

A montage of headlines for the 1928 Notre Dame-Navy game.

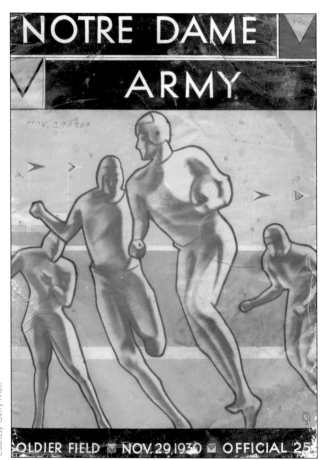

Cover from the 1930 Notre Dame-Army game program.

HERE COME DA BEARS

The Bears came to Soldier Field in 1971; their capacity of 45,000 at Wrigley Field had become too small, and 60,000 salable seats at the venue on the lakefront meant significant new revenue despite nonideal sightlines. The Bears were never truly happy with Soldier Field, however, and often talked of a new stadium. Several proposals vaguely captured the public's fancy, but never the imagination of successive mayors. The Bears said that maybe they should leave Chicago, perhaps for Arlington Heights, where they could build a new stadium and attract new fans, an idea that provoked Mayor Richard J. Daley's anger but did nothing to resolve the problem.

The first Mayor Daley died in 1976 and was followed by Mayor Michael Bilandic, who proposed linking a new football stadium to a racetrack, as had been done in the New Jersey Meadowlands. Talk ceased when he discovered that Illinois racing taxes made this idea nonviable. In 1979, Mayor Byrne, who had little interest in football, replaced Bilandic.

The Bears were impatient. Other teams were getting new stadium deals, selling skyboxes at exorbitant rates to rich businesses. Bears owner and president Michael McCaskey often skirmished with the city over anything

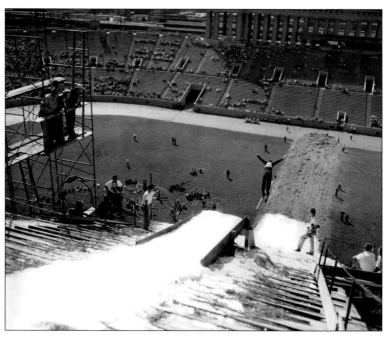

Soldier Field was beleaguered by disuse from an early point in its history.
Skiing on the east grandstand was one idea for the city's largest stadium, but
like midget car racing and demolition derbies, it had a short run. In 1954, a
ski jump was erected, and competitors came from around the world.

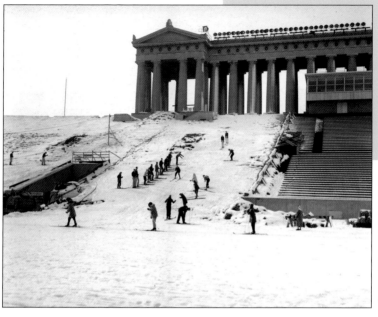

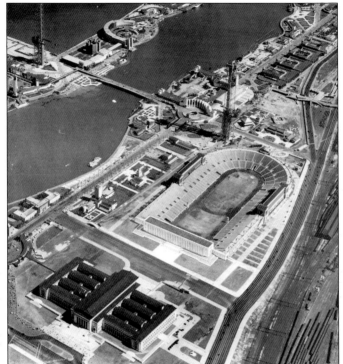

On this strip of reclaimed land, Burnham Park developed by increments. Northerly Islands, a few yards out in the lake, was built for the 1933 World Fair. In 1939, the Park District built its headquarters on the north end of the stadium. In 1948 (after this photograph was taken), Meigs Field occupied the island and Lake Shore Drive was bifurcated at Soldier Field and the Museum. The next major change occurred in 1996, when the Museum Campus project reunited both lanes of the Drive in an undeniably successful effort at beautification.

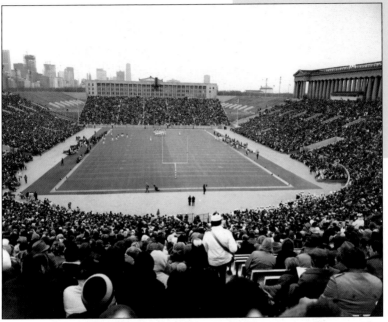

Courtesy Chicago Park District Archives

In a variety of retrofits for a structure that had become an undeniable white elephant, the Park District constructed a grandstand just beyond the north end zone to accommodate the Chicago Bears in 1971. After a number of other improvements, it served as the home field for the 1985 NFL champions.

from the revenues from beer to primitive showers for athletes. Eventually, the Park District made it possible to build wooden skyboxes around the terraces of Soldier Field, although the paint soon faded on their exteriors and they looked more like trailers than luxury suites.

The Bears' 1986 Super Bowl triumph increased agitation for a new stadium. Looking for a solution, Governor Jim Edgar came up with an idea nicknamed "McDome," first suggested in 1989 for property on the edge of McCormick Place. The idea was an indoor stadium primarily for the Bears but also for other attractions like ice shows and concerts. The legislature wouldn't finance such a project, however.

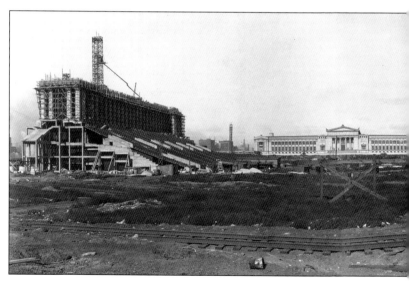

Mayor Richard M. Daley, elected in 1989, developed the idea that eventually set the scene for an improved Soldier Field. But getting there was neither easy nor harmonious. The low point was in 1995, when the Bears considered the apparently preposterous option of moving to Gary, Indiana. The plan died, but the Gary gambit activated a new wave of design activity. A quiet initiative, for example, was undertaken in 1996 when McCaskey invited NFL team owners and many architects to Bears headquarters for a seminar on the general subject of football stadium design. Included was the small Boston design firm of Wood + Zapata, which had worked on the Gary scheme. Tony

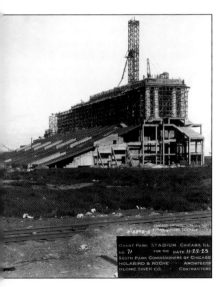

With the ethereal Field Museum in the background, modern reinforced concrete poured from movable towers was used for this addition to "Paris on the Prairie," as the Chicago of Daniel Burnham's imagination was called.

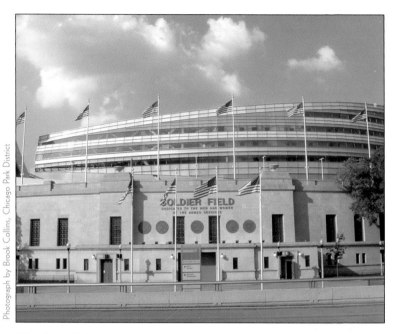

When Soldier Field was being redesigned, there were notions to sell "naming rights" to a high-bidding corporation. But in the political maelstrom that led to the new stadium, the old name was preserved, as was the stadium's role as a civic monument.

Montalto, lead designer on the renovation for Wood + Zapata, recalled that the meeting was more valuable for the architects than for the owners. Most owners had little interest in cutting-edge design. But architects new to sports realized with new acuity the importance of football's bottom line. Good architecture was a luxury; high priorities were spiffy skyboxes and even efficient systems to tap brewed beverages.

Landing on the Park

In 2000, the city and the Bears together unveiled plans for a renovated Soldier Field. What had changed in the intervening time was that the old stadium had deteriorated to an extreme state. Perhaps more importantly, the Bears had a new president, Ted Phillips, who was commonly described in the media as "affable" (as opposed to McCaskey, who was unfairly characterized as aloof). Happily, City Hall and the Bears were now reading from the same playbook. Not too surprisingly, opponents were preparing for a blitz of their own.

Absolutists had long suggested razing Soldier Field altogether and dedicating the site as additional precious parkland. More realistically, the preservation group Friends of the Parks now voiced claims that the stadium would violate the

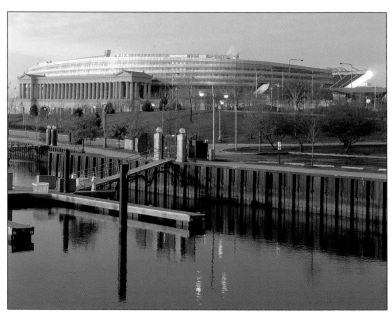

The Stadium in a Park, as its owners call it, stands on the edge of Burnham Harbor.

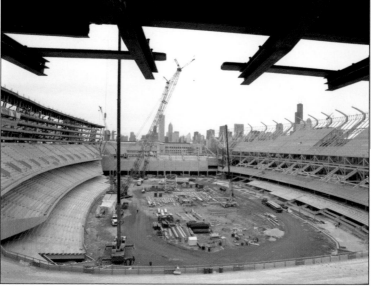

Photograph by Douglas Reid Fogelson

A stadium that would become colorful and festive began as something gray and utilitarian—
and a political horror as lawsuits to stop construction proceeded even after construction
had begun. (Lawsuits were dismissed before construction reached this point.)

age-old covenant that the lakefront remain "open, clear and free." On these and other grounds, Friends eventually filed lawsuits to stop construction. Also disturbing at the time, the Interior Department announced that the stadium's National Historic Landmark status could be revoked if renovation changed its essential character. Most prominently, the *Tribune* staged an angry editorial campaign against the project, although its critical epithets like "Mistake on the Lake" and "Monstrosity on the Midway" were more polarizing than useful and did nothing to influence or improve the stadium that finally went up.

The project moved forward. The state legislature finally allocated more than half the money needed. The Bears invested $100 million, the NFL another $100 million. The mayor and the Park District also pushed the plan. The $600 million-plus project looked ready to go even as criticism grew. In fact, lawsuits were unresolved when interior demolition and construction of the new Soldier Field began.

DYNAMIC — IF IMPERFECT — DESIGN

While some Chicagoans were riled by the thought of any new stadium on the lake, and its architecture was torn apart by many others, the Soldier Field project was the result of a serious partnership of two distinguished firms. The design group LW+Z was a consortium of Chicago's Lohan Caprile Goettsch, which did the master planning, and the Boston (now New York) firm of Wood + Zapata. The new configuration evolved primarily as design-

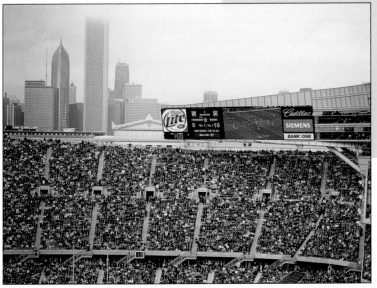

Photograph by
Douglas Reid Fogelson

Chicago architecture has long mixed its big shoulders with an ability to reach for the sky. Old Soldier Field was all about stolidity and strength. The new stadium was designed partly as a lofty stage for the city's skyline.

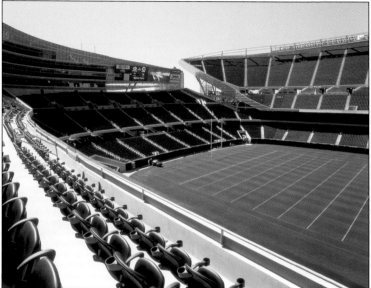

The architects were intent on breaking the mold of stadium design, an opportunity
that presented itself as they were challenged to fit a new stadium inside the old.
Asymmetry was part of the answer, which the architects believe may foreshadow
a new approach to the way gridiron stadiums are built.

ers concluded that a conventional oval would not fit inside the 80-year-old colonnades (and when the client accepted capacity reduced to 62,000). A unique and asymmetrical design was the answer, in this case with an oversized grandstand on the one side of the field and a stack of skyboxes and premium club seats on the other.

The result: within the old concrete bowl rises an ultramodern structure of gleaming surfaces and dramatic sculptural form. From the inside in particular, Soldier Field almost flaunts the latest technologies—from its daring steel frame (designed with computer modeling) to low-reflectivity glass in the suites. Sightlines are good all around; but the gridiron is not the only thing of interest for spectators to look at. Soaring cantilevers and theatrical openings to skyscrapers in the distance might often be more memorable than the game on the field.

It's not perfect, of course. The west grandstand rakes nine stories high over the west colonnade, making the once powerful classical element look insignificant. Sadly, it's not even that these and the other problems were unresolvable. Theoretically, the entire structure might have been lowered, but sinking the structure and installing slurry walls to keep out lake water would have cost millions more.

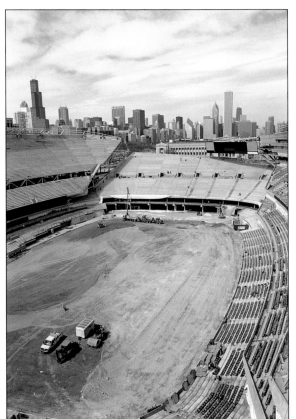

On a steel frame the structure was assembled from sections of precast concrete, an economical technology that also met stringent deadlines for completion for the 2003 football season.

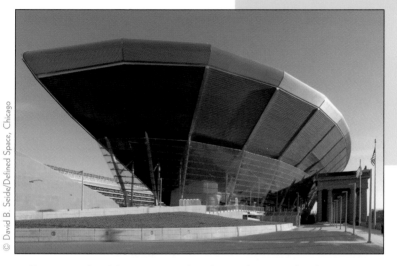

The west grandstand demonstrates—perhaps flaunts—the power of modern construction.

The east (right) and west sections of the new stadium are distinct. In
the context of Chicago architecture, the former gets high marks for sleek
modern lines. The other side will simply take some getting used to.

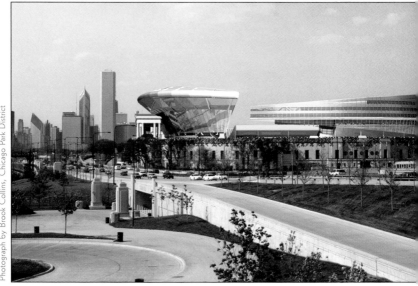

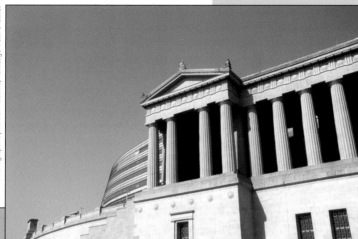

The east facade of the new stadium is its grandest and most hand-
some. The 1924 colonnades are prominent. The glass walls of
the twenty-first century appear dynamic in the background.

Also controversial is the fact that the skybox and club seat occupants on the east are distinctly separated from the grandstands on the west. This solution was critical, the architects insist, to achieve what is good about the design. Yet, what if skybox suites had been built over Lake Shore Drive and the tracks on the west, not next to the lake on the east? Simply reversing the scheme would have given corporate tenants a less pleasant view, but it seems undeniable that the view of the stadium from the city would have been far more flattering.

Most people are not disappointed, however. The new stadium was designed from the inside out. "Our sole purpose," Wood wrote, "was to make the stadium a great experience for the fans. The sightlines are unequaled." The kinetic geometry of the structure also optimizes sightlines. Upper terraces rake at a sharp angle from the ground; the skyboxes rake forward so that each successive story juts out a little more toward the field.

On Chicago's Front Yard

Naturally, it wasn't the interior that concerned the detractors of the Soldier Field renovation. It was the greater space of the park, the lakefront, and the city's "front yard." Park advocates, primarily Friends of the Park, still insist that Soldier Field resembles a spaceship that has landed on the gentle swards of Burnham Park. The architects counter that many of those gentle swards did not exist prior to the redevelopment of Soldier Field and its "North Burnham Park" confines. This fact is emphasized by the architects, particularly the office of

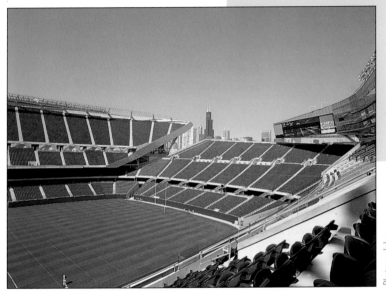

Photograph by
Douglas Reid Fogelson

It was no accident that a 35-year-old icon, Sears Tower,
became a design element for Chicago's new football venue.

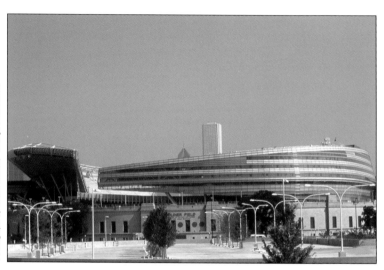

A view of the south end, where the improvements over acres of macadam include more parking and a "hard surface" for circus tents and other nonsporting events that have long used this section of Burnham Park.

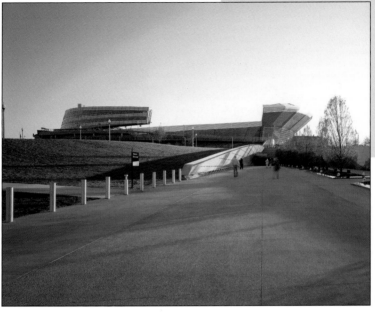

Photograph by Douglas Reid Fogelson

From some approaches to Soldier Field, such as this one from the north, the old stadium has been overshadowed and largely concealed by a new configuration of cantilevers and naturalized landscape.

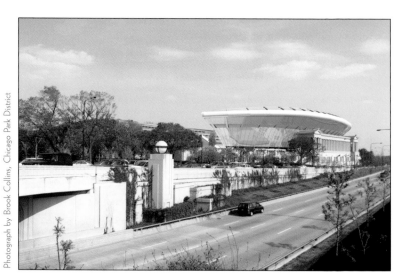

Beautification around the new park and along Lake Shore
Drive echoes the neoclassical style of the 1924 stadium.

Lohan Caprile Goettsch, which is primarily
responsible for the master plan that cre-
ated or enhanced a park in which a stadium
was placed.

With the nearby aquarium and plane-
tarium additions to its credit, plus an
early (1987) plan for the Museum Campus,
the Lohan office had the natural objective
of blending a useful football stadium into a stately park setting that had
already become an architectural showplace. A major and perhaps pivotal
decision was to build underground parking on the stadium's north end, just
south of the Field Museum, which the garage would also serve; this necessi-
tated demolition of park headquarters. It was replaced by a rolling grove of red
oaks, hybrid elms, and maples, along with the native species already on site.

Other elements of the landscaping—executed by the Chicago firm of Peter
Lindsay Schaudt—encourage use by children and families and include a nau-
tilus garden (a spiral walk with plants and child-friendly sculpture) and a sled-
ding hill. In effect, the park surrounding Soldier Field encourages pedestrians,
despite a wide service road that cuts through north and south. The overall
design is rolling and curvaceous, playing off the new, modern stadium more
than the old, classical one. A Beaux Arts landscape in the spirit of the Holabird
and Roche design might be two dimensional and predictable; Schaudt's design

of mounds and groves is not—he claims that he was inspired more by the freeform of glass and steel in the stadium.

But whatever else visitors experience at Soldier Field, they will glimpse images of something that had been hidden or ignored for years: evidence that Soldier Field is a civic space and war memorial. The first Soldier Field was a memorial for those lost in World War I. The renovation continues this role, thanks to the Bears' pledge that the name remains Soldier Field, not that of a paying sponsor. Now a memorial wall on the north entrance of the stadium and a restored Doughboy statue inside the stadium at the south end memorialize the military more conspicuously than ever.

A PROJECT OF MANY PARTS

So this is it: Soldier Field, Chicago's first major structure of the twenty-first century. And despite controversies and despite the effect of a beloved twentieth-century design (influenced by nineteenth-century architectural fashion), the stadium is here to stay. As with all modern architecture, only time will tell if it is a truly successful design, beloved by the people who use it, influential to architects who are commissioned to create something like it. But already it has made its mark.

Soldier Field is indeed a place to play and watch football, and a memorial to veterans fallen in a long-ago war. It is also a reminder, however, that architecture serves many constituencies, whether powerful (team owners, city hall), acerbic (critics of all stripe), or dedicated to a livable city (Friends of the

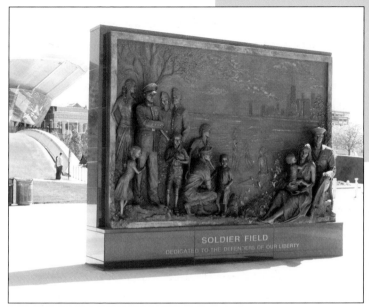

Tribute to Freedom was created to accompany the stadium's Memorial Water
Wall. This bronze sculpture by the Koh-Varilla Guild of Chicago honors not just
the soldiers who have fought in foreign wars but the families that they left behind.

Parks). We need to remember the process that got Soldier Field designed,
because in any work of public architecture, the way the many people who
influence design behave is at least as important as the engineering of concrete,
glass, and steel.

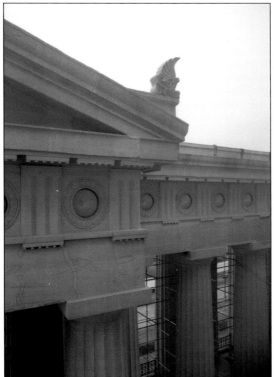

The lamps in the frieze are a reminder that night events at Soldier Field were played in semidarkness beneath the romantic profiles of lofty ornaments and Doric columns.

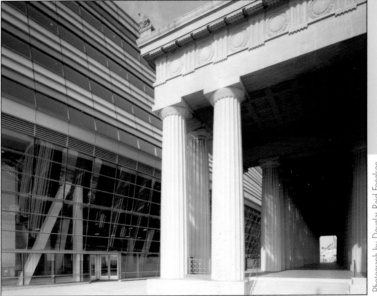

The original stadium exhibited skill at re-creating the details of classical order, with triglyphs in the frieze and acroteria over the eaves.

Photograph by Douglas Reid Fogelson

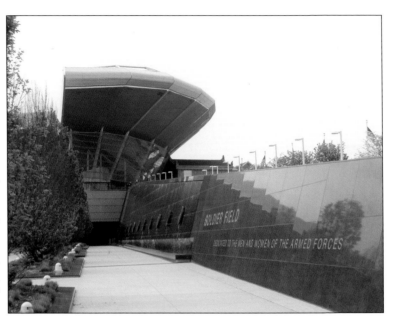

The approach along the Memorial Wall has a quiet monumentality that echoes the character of old Soldier Field, concealed from some vantage points but never forgotten.